contemporary+cutting edge: pleasures of collecting, part III

contemporary+
cutting edge:
pleasures of collecting, part III

Nancy Hall-Duncan
Peter C. Sutton

BRUCE MUSEUM, GREENWICH, CONNECTICUT

This catalogue is published in conjunction with the exhibition *Contemporary+Cutting Edge: Pleasures of Collecting, Part III*, organized by the Bruce Museum, Greenwich, Connecticut, September 29, 2007–January 6, 2008.

Printed by Kirkwood Printing Company, Wilmington, Massachusetts
Catalogue designer: Anne von Stuelpnagel
Project coordinator: Kathy Reichenbach
Registrar: Jack Coyle

ISBN 0-9766381-4-2

Cover (front):
Cat. 32
E. V. Day (American, 1967–)
Bridal Super Nova, 2005
Various fabrics and accessories, monofilament, welded powder-coated steel cage and stand
42 x 42 x 40 in.; overall height 80 in.
Private collection

Cover (back):
Cat. 10
Jean-Michel Basquiat (American, 1960–1988)
Untitled, 1982
Signed and dated on verso *Jean-Michel Basquiat 1982*
Acrylic and oilstick on canvas, 68 7/8 x 80 11/16 in.
Collection of Leslee and David Rogath

Page 5
Cat. 34 (detail)
Hilary Harkness (American, 1971–)
Pearl Trader, 2006
Oil on linen, 30 x 33 in.
Collection of Jennifer Blei Stockman

The exhibition and its catalogue are generously underwritten by

Lehman Brothers

The Charles M. and Deborah G. Royce
Exhibition Fund

Lehman Brothers has a strong commitment to contemporary art.

At Lehman Brothers we believe that we all need to be inspired. The contemporary arts in particular encourage us to always stay current, embrace the ever-changing, and to see the world in new and different ways.

Often the most meaningful and significant inspiration comes from those around us. *Contemporary+Cutting Edge: Pleasures of Collecting, Part III* at the Bruce Museum represents a rare and exciting opportunity to view works by major artists of the late twentieth and twenty-first centuries on loan from the private collections of local area residents. This window into what others appreciate will challenge our thinking, broaden our perspective and spark our own creativity.

Lehman Brothers and Neuberger Berman, a Lehman Brothers company, are proud to support this important exhibition. We salute the Bruce Museum's initiative in bringing this collection of works together, as well as the lenders themselves whose contributions made this idea a vivid and vibrant reality for many to enjoy.

LEHMAN BROTHERS

NEUBERGER | BERMAN
A Lehman Brothers Company

The Bruce Museum is privileged to reside in a community that has perhaps the highest per capita concentration of art collectors in the world. A happy by-product of this situation is the exceptional abundance of local resources of privately owned art. The Museum and our visitors have regularly benefited from these holdings; we have featured several of the premiere private collections in our exhibition schedule in recent years. And *Contemporary+Cutting Edge* is the third in a series of group shows drawn from multiple local collectors, hence it is subtitled *Pleasures of Collecting, Part III*, a series that has surveyed art from the Renaissance to tomorrow. Greater Greenwich is fortunate not only to be an affluent community with the resources to collect art but also home to some of the most astute and adventurous collectors anywhere, individuals who keenly follow the Contemporary art scene, plot the trajectory of art's future, and often patronize living artists. They naturally benefit from the proximity to New York City, still the capital of the art world, but they have also invested the time and attention to become truly informed, active collectors.

Works in this show briefly review the underpinnings of the art of today with representative examples by artists who have entered the modern pantheon of Contemporary art— Jasper Johns, Jim Dine, James Rosenquist, Andy Warhol, Roy Lichtenstein, Cy Twombly, Sol LeWitt,

preface

Jean-Michel Basquiat, Joan Mitchell and Chuck Close. We then explore the rich heterogeneity of the art scene in the last two decades of the twentieth century, with works by artists like Gerhard Richter, Ed Ruscha, Kiki Smith, Damien Hirst, Louise Bourgeois, Richard Prince, Gavin Turk, and Nicolas Africano. Finally we reconnoiter briefly amidst the youthful art of the new century with recent works by Petah Coyne, Ron Mueck, Grayson Perry, Vanessa Beecroft, Laurie Simmons, E.V. Day, Marc Quinn, Mahomi Kunikata, Sarah Lucas, and Joshua Mosley. The works in the show challenge traditional notions of what constitutes the parameters, media, and subject matter of art. Many are thought-provoking and some deliberately audacious, pushing the envelope of artistic convention. They test our assumptions about art while attesting to the dazzling variety, invention and boldness of the art of the recent past and present. We offer here burnished "art stars," whose names have long since passed from the lips of artistic *cognoscenti* to the society pages and households, as well as newly minted talents, whose legacies hang in the balance yet to be fully weighed.

We are deeply indebted to our lenders, not merely for their generosity in sharing their art with us but also for the time they have devoted in seeking out the most expressive and eloquent examples of what is new, current and soon-to-be. Many traditional collectors find comfort in collecting older art, works that have stood the test of time and can be evaluated, as it were, at arm's length. By contrast, the collector of Contemporary art is often so close to the moment of the work's conception as to be forced to create their own perspective on its merits. They may go on studio visits and can form personal relationships with living artists. They must be open minded to grasp new and emerging artistic concepts, indeed must sometimes suspend their disbelief and occasionally take a leap of faith. For their adventurous spirit and willingness to share we are abidingly grateful.

I also want to extend our heartfelt gratitude to Lehman Brothers, who have generously underwritten this show. We welcome them to Greenwich as they open their new office here, which will be run by the Bruce Museum's own Trustee, Mary Mattson Kenworthy. As always a special debt is owed Chuck and Deborah Royce, who in their far-sightedness endowed an exhibition fund that helps support all the major shows we mount here at the Bruce. We also wish to thank the many gallery owners who advised and assisted our staff in the assembly of these works and in obtaining reproduction rights. Finally, I wish to thank our staff, notably Nancy Hall-Duncan for ably overseeing the show, Anne von Stuelpnagel for her inspired designs, to Jack Coyle our Registrar, Rick Larkin and the Development staff, and Kathy Reichenbach for administrative assistance *par excellence*. I hope you enjoy the show and come away challenged, moved and refreshed.

Peter C. Sutton, The Susan E. Lynch Executive Director

Contemporary+Cutting Edge: Pleasures of Collecting, Part III addresses art from the period 1960 to the present, a time that historian and writer Edward Lucie-Smith has called the "the richest, most controversial and perhaps most thoroughly confusing epoch in the whole history of the visual arts." This exhibition addresses this rich diversity of artists, media, nationalities and types of art—from easel painting and traditional sculpture, through photography, video and performance art as well as the fabrication of extraordinary objects from a taxidermied dog to painted sushi. The artwork presented incorporates all manner of media, from bridal wear to cigarettes, expanding our sense of appropriate subject and content in art.

Major artists of the late twentieth century are richly represented in this exhibition. Classic work of the 1960s includes James Rosenquist's *Trophys of an Old Soldier* and Jim Dine's *Colorful Hammering* of 1962, a period in which he was combining painting and objects with highly emotional and personal content. A large painting by Pop artist Andy Warhol entitled *Blue Mona Lisa* reflects the artist's obsession with mass culture, taking as its subject the most recognizable painting in Western art.

contemporary+cutting edge: pleasures of collecting, part III

Among other important works are two artists who have pushed the realist tradition in new directions: David Hockney's *Outpost Drive, Hollywood*, 1980, which also showcases his brilliance as a colorist, and Chuck Close's touching portrait of his daughter Georgia, an example made of handmade paper. Late twentieth-century abstraction is represented by Joan Mitchell, a second-generation Abstract Expressionist, with the bold, color-laden gestures of *Chord VII*, and Gerhard Richter's *Untitled, 26/9/85 (2)*, a bold and sensuous geometric abstraction. Ed Ruscha's *Metro, Petro, Neuro, Psycho* demonstrates the post-modern use of words as an artistic element in late twentieth-century art, a concept whose legacy has decended from Picasso to Marcel Duchamp to Jenny Holzer.

Some of the most interesting, exciting and provocative recent art is included in this exhibition. An international roster of artists representing different aspects of contemporary art will be featured, including a sampling of the so-called Young British Artists, who rose to fame with the

notorious 1997 *Sensation* show at the Royal Academy in London. Damien Hirst, the British artist whose shark, *The Physical Impossibility of Death in the Mind of Someone Living*, created such a stir in this exhibition, is represented here by a virtually as memorable domestic lamb (*ovis aries*) preserved in a formaldehyde solution. Entitled *Away From the Flock* (1994), it is one of the highlights of the exhibition. Its presentation in a glass box—half scientific specimen, half homage to the Minimalist object—recalls both the natural history museum and their specimens in preservative-filled jars. The lamb addresses issues of life and death, past and present, recalling both the bucolic imagery of rural England and the loss of innocence in the world of contemporary scientific inquiry.

Also in the exhibition is a Damien Hirst "spin" painting, *Beautiful Blue Comet Hurling Towards the Center Painting (with Pastel Hues)*. Hirst's "spin" paintings, a series begun in 1995, were created by pouring paint onto a large rotating, circular canvas. The long, wordy titles reflect the excesses of the series, matching the gigantic size, brilliant color and gaudy juxtaposition of hues.

Another of the Young British Artists is Sarah Lucas, whose work shows contempt for the concept of fine art in its choice of found objects and common materials. *Gnorman* (2006), constructed of a plastic cast gnome and cigarettes, thumbs its nose at artistic refinement and elevated taste. Gavin Turk is represented by *Death of Marat* (1998), a life-size sculptural work in which the artist represents himself in the pose of Jacques-Louis David's famous 1793 painting showing the French Revolutionary stabbed in his bathtub. Appropriating this iconic art historical image, Turk both links his art with that of the past and raises important issues about authorship, authenticity and originality. The idea of appropriation as it is used in twentieth century parlance extends back to Marcel Duchamp and links Turk with other contemporary artists such as Richard Prince, who is represented here by one of his famous Marlborough man quotations.

The exhibition illustrates the diversity of media used in contemporary art in work by such artists as Grayson Perry. *He Comes Not in Triumph* (2004) is one of Perry's glazed ceramic pieces, which are both topical and technically dazzling. The artist utilizes richly textured designs marked into the clay with luster, gold leaf and intricate glazing and photo-transfer techniques. Yet Perry's work is not merely decorative pottery, since he combines time-honored shapes with images that are provocative in their political, sexual or social commentary. In 2003 Perry was awarded the Tate's Turner Prize, one of the most important and prestigious awards for the visual arts in Europe. His acceptance of the award was as unconventional and audacious as his work: Perry's

transvestite alter ego, Claire, received the Turner Prize dressed in a "coming out" frock of embroidered mauve satin, teamed with white ankle socks and red patent-leather Mary-Jane shoes.

Performance, video and "sound" art are well represented in the show. The inclusion of Joshua Mosley's video *dread*, the sensation of this year's Venice Biennale, is noteworthy. The piece is composed of five bronze sculptures and a mixed media animation in which the three-dimensional, scanned clay sculptures are animated in a landscape of stop-motion photography. The piece is set to an original score composed by the artist. The animation takes the form of a sylvan encounter between the French philosophers Blaise Pascal and Jean-Jacques Rousseau, who are unable to resolve their different perspectives on the nature of things. They continue into darker territories of increasing differences. Christian Marclay, a noted musician and sound artist, is represented by *Silence*, a potent work which comments on many aspects of contemporary society by alluding to Andy Warhol's famous *Electric Chair* series. Vanessa Beecroft's photograph, *VB52, Castello di Rivoli*, documents the artist's 2003 performance at Turin's Museum of Contemporary Art. Beecroft addresses feminist and autobiographical issues using clothed and nude models (often in her own image) to comment on a variety of contemporary questions.

Beecroft is one of several artists in the exhibition who address the diverse feminist perspectives of Contemporary art. E.V. Day shot to art world prominence in the 2000 Whitney Biennial with *Bombshell*, which deconstructed a copy of the famous dress Marilyn Monroe wore in *Some Like It Hot*, making it appear as if it had just exploded. Her work continues to comment intelligently and often hilariously on feminine stereotypes, as here where the explosion of a wedding gown appears to have created a white-hot super nova. Sculptor Kiki Smith deals powerfully with the issue of female subjugation in *Daisy Chain* while Marc Quinn is represented by *Sphinx (Fortuna)*, his 2006 sculpture in which the body of supermodel Kate Moss is twisted into an impossible contortion, thereby questioning the standard of beauty and its limits in our society. Quinn is known for his provocative and thought-provoking sculpture, including the large-scale public sculpture installed in Trafalgar Square, London, showing the disabled British artist Alison Lapper, nude and eight and a half months pregnant.

The exhibition shows the importance of sculpture and how varied both its subject and form have become in Contemporary and Cutting Edge art. From Louise Bourgeois' monumental spider—a powerfully symbolic, unexpectedly maternal subject which is one of the highlights of the exhibition—to Sol LeWitt's classic minimalist sculpture to the recent work of Mahomi Kunikata entitled *Maho Sushi Favorite Assortment* and Jeff Koons's painted skateboard, the exhibition

includes work to engage and stimulate art lovers of all ages and the most diverse tastes. Ron Mueck, whose sculpture was featured in a major retrospective at the Brooklyn Museum this year, approaches representational portraiture with startling originality. Mueck forces the viewer's attention with his use of unusual scale, from unexpectedly small to breathtakingly large, and by his unflinching look at moments rarely pictured in art, from moments after birth (his outsized just-born babies) to the torpor of death (in his most famous work, *Dead Dad*).

Contemporary+Cutting Edge: Pleasures of Collecting, Part III offers a tantalizing glimpse into a number of the finest contemporary collections in the world and an unprecedented chance to view world-class art that is privately held in these collections. While making no claims of being inclusive, the work in the show systematically spans the last fifty years of artistic production, from Pop Art, second-generation Abstract Expressionism and minimalism to the most recent manifestations of Post-Modernism. The white-hot work of the moment is well represented, including six examples made in 2006 by Marc Quinn, Jeff Koons, Hilary Harkness, Mahomi Kunikata, Christian Marclay, and Sarah Lucas, as well as the 2007 mixed media installation *dread* by Joshua Mosley, which is currently on view at the 2007 Venice Biennale. The exhibition illustrates that the artists and type of art they make has changed dramatically since 1960, and the ideas addressed and the meanings conveyed have expanded exponentially. Undoubtedly, they will continue to do so throughout the twenty-first century, most likely in ways that are beyond imagination today.

Nancy Hall-Duncan, Senior Curator of Art

1 J I M D I N E (American, 1935–)

Colorful Hammering
1962
Oil on canvas, wood and hammer
60 3/8 x 51 in.
Private collection

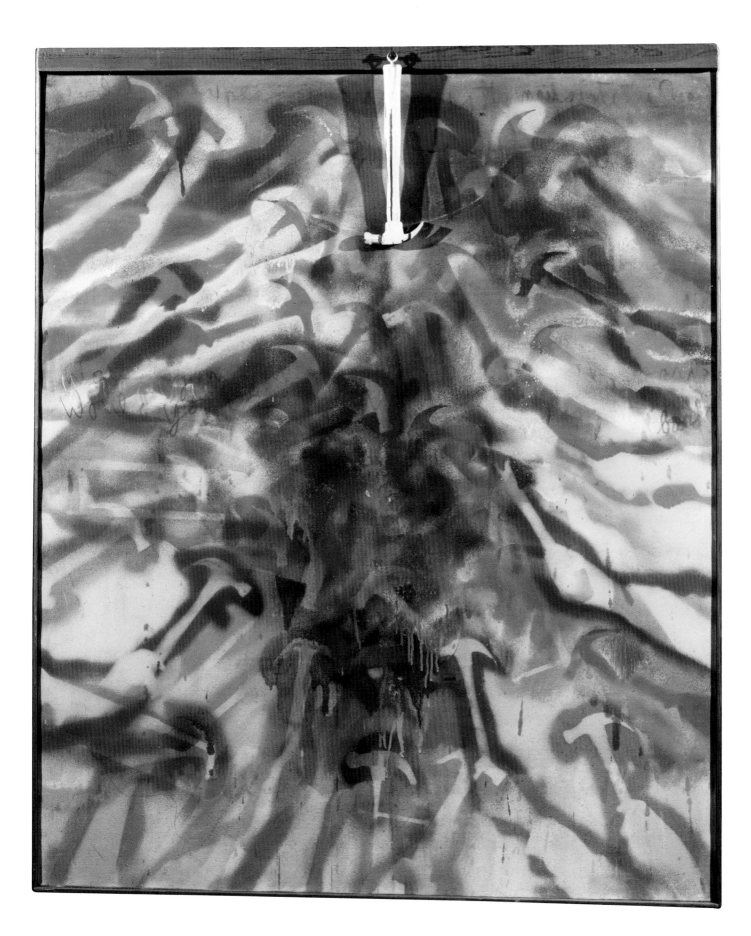

2 J A M E S R O S E N Q U I S T (American, 1933–)

Trophys of an Old Soldier
1962
Oil, twine and metal hooks on canvas
56 x 48 in.
Private collection

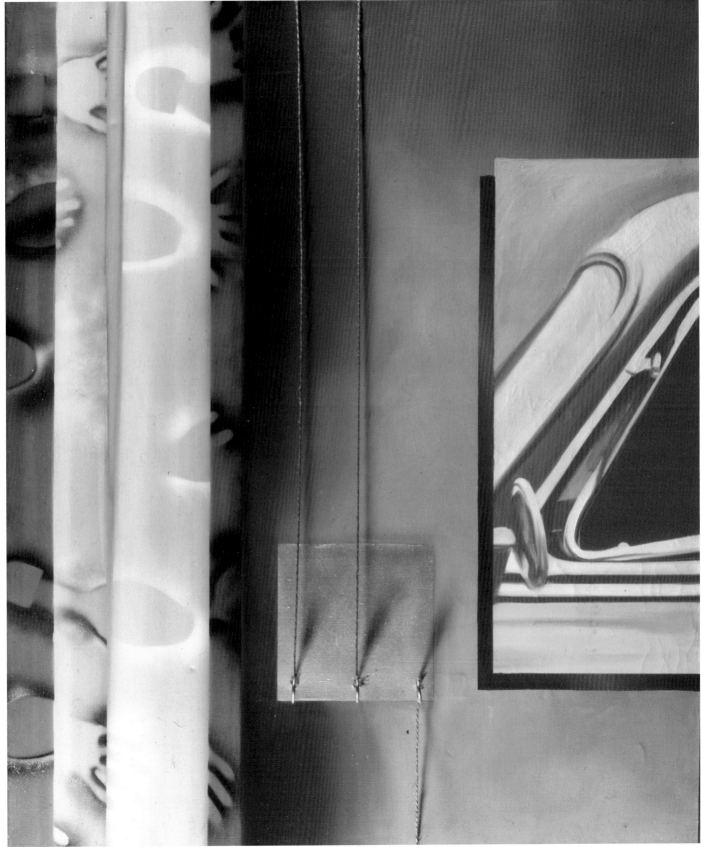

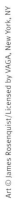

3 E V A H E S S E (American, 1936–1970)

Boxes
1964
Acrylic, gouache, pen and ink and graphite on paper
23 1/2 x 19 3/4 in.
Private collection

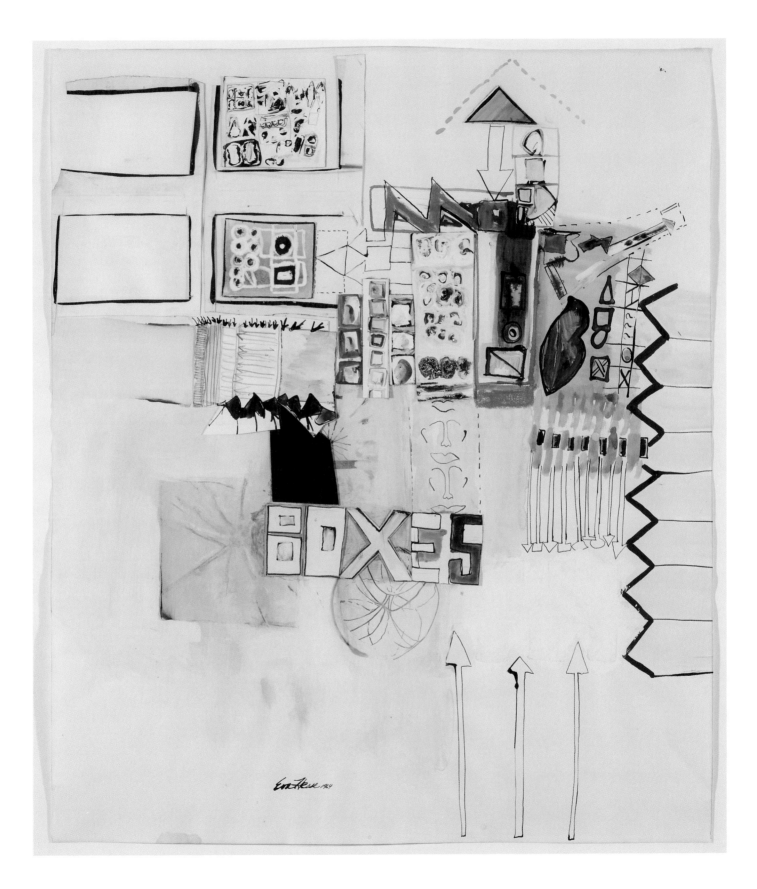

4 N E I L J E N N E Y (American, 1945–)

Wet and Drying
1970
Acrylic on canvas
35 1/4 x 74 1/4 in.
Collection of Monica and Rick Segal

5 S O L L E W I T T (American, 1928–2007)

Photogrid collage
1978
Polaroids mounted on board
Signed and dedicated to Herbert and Virginia Lust,
lower left
38 x 28 1/2 in.
Collection of Herbert and Virginia Lust

23

6 S O L L E W I T T (American, 1928–2007)

Modular Open Cube
1978
Acrylic enamel on wood
15 1/2 x 60 x 15 1/2 in.
Collection of Herbert and Virginia Lust

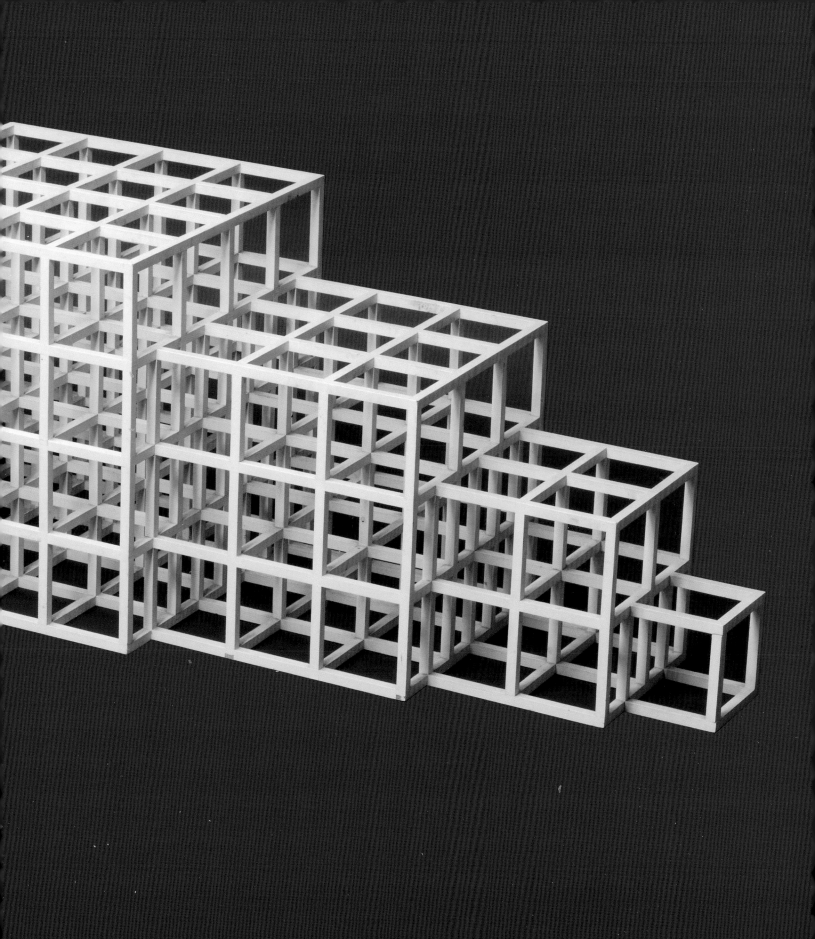

7　A N D Y　W A R H O L　(American, 1928–1987)

Blue Mona Lisa
1978
Acrylic, gel medium and silkscreen inks on canvas
50 x 40 in.
Private collection

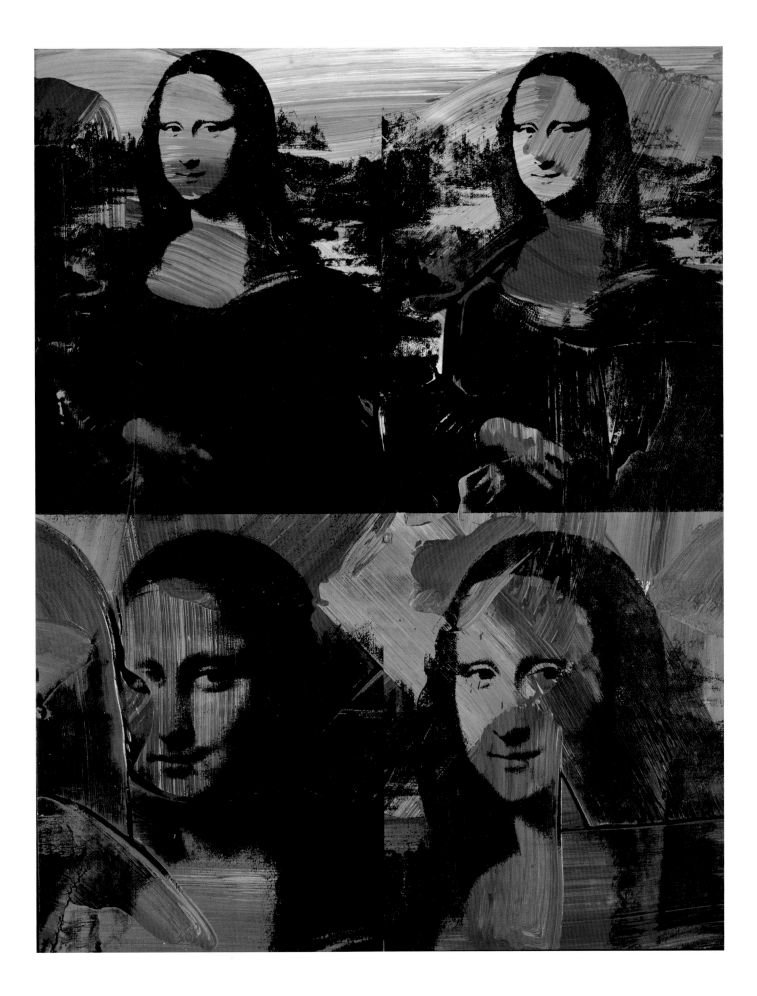

8 S A U L S T E I N B E R G (American, 1914–1999)

American National Bank
1978
Colored pencil and ink on paper
16 x 22 1/2 in.
Collection of Leslee and David Rogath

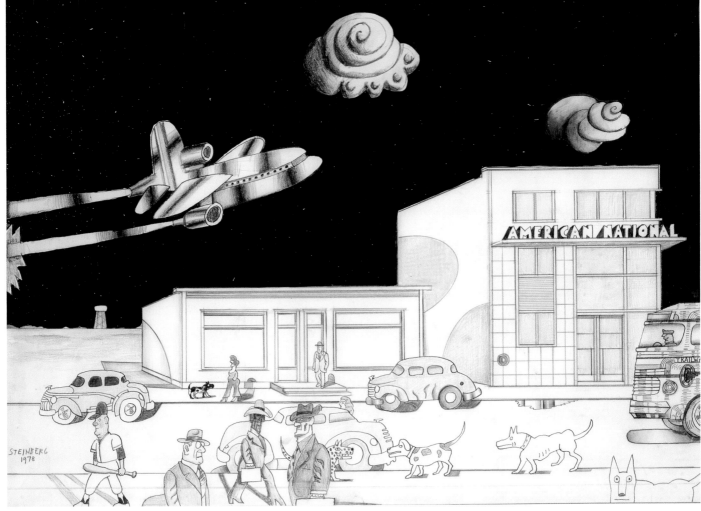

9 D A V I D H O C K N E Y (British, 1937–)

Outpost Drive, Hollywood
1980
Acrylic on canvas
72 x 72 in.
Collection of Leslee and David Rogath

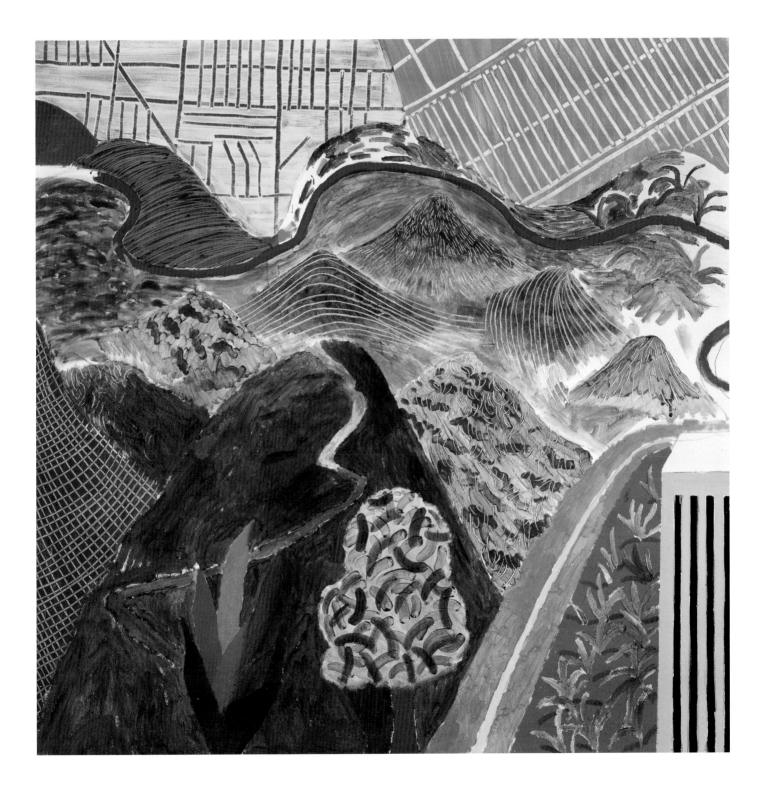

10 JEAN-MICHEL BASQUIAT (American, 1960–1988)

Untitled
1982
Signed and dated on verso *Jean-Michel Basquiat 1982*
Acrylic and oilstick on canvas
68 7/8 x 80 11/16 inches
Collection of Leslee and David Rogath

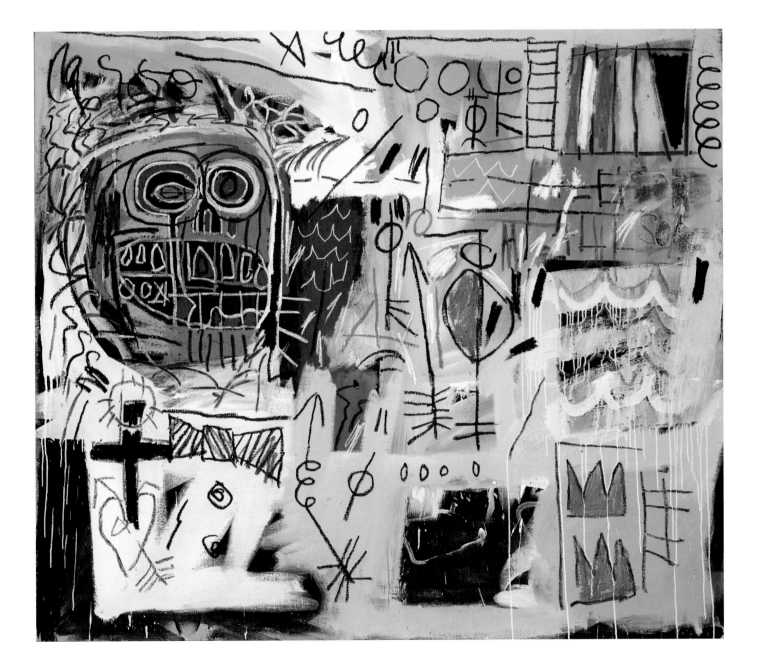

11 C Y T W O M B L Y (American, 1928–)

Formian Dreams and Actuality
1982–83
Oil paint and crayon on paper
39 3/8 x 27 1/2 in.
Private collection

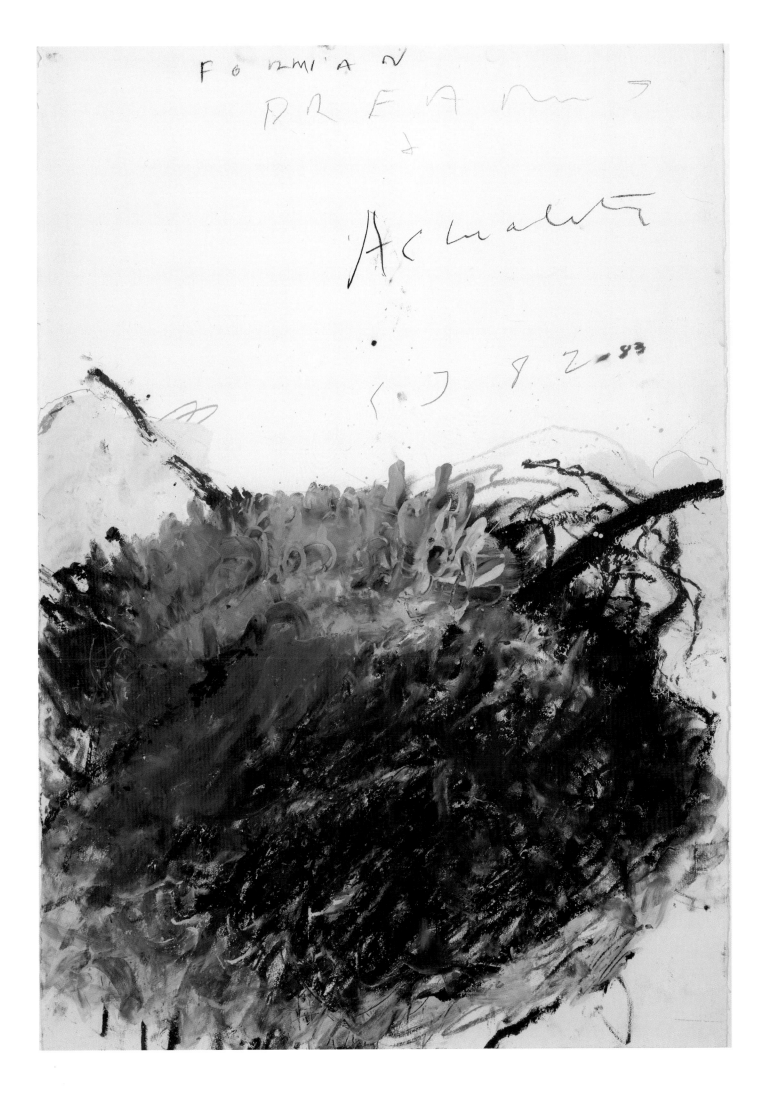

1 2 C H U C K C L O S E (American, 1940-)

Georgia
1984
Handmade paper, air dried
Edition 3/35
56 x 44 in.
Private collection, New York

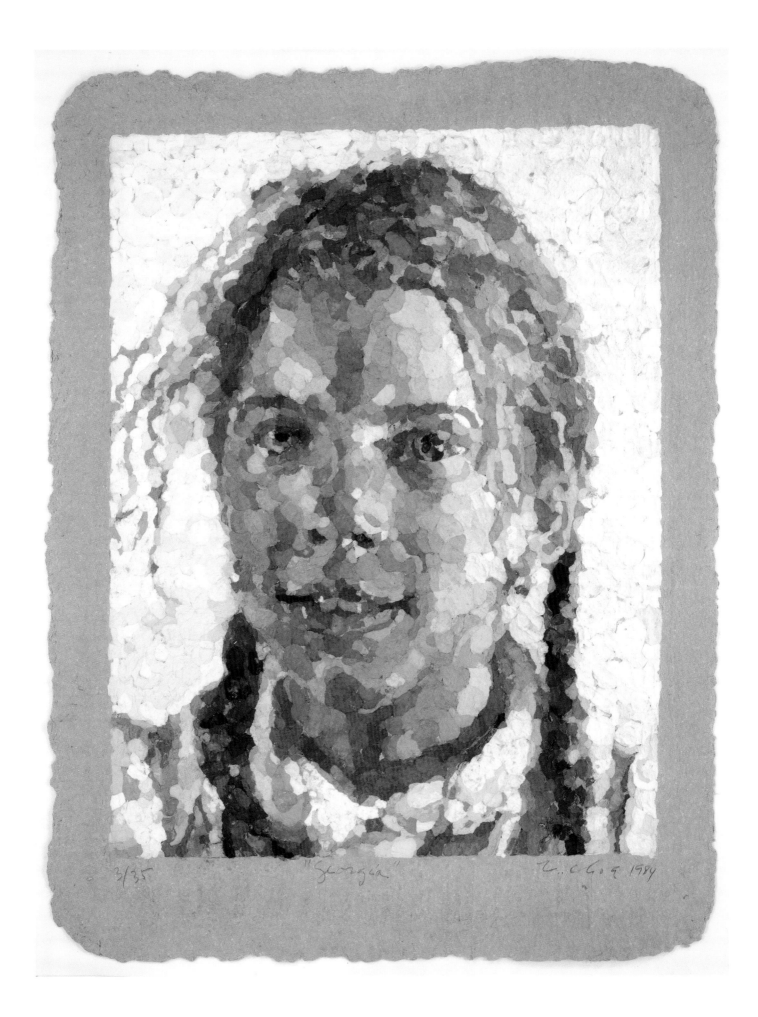

3/35 "Georgia" L. C. Go q 1984

13 G E R H A R D R I C H T E R (German, 1932–)

Untitled, 26/9/85 (2)
1985
Oil on paper on board
22 1/2 x 34 3/8 in.
Private collection

1 4 J A S P E R J O H N S (American, 1930–)

Summer
1985
Graphite on paper
11 13/16 x 9 1/16 in.
Private collection

15 ROY LICHTENSTEIN (American, 1923–1997)

Imperfect Paintings
1987
Oil and magna on canvas
Diptych, 60 x 48 in. and 60 x 56 in.
Private collection

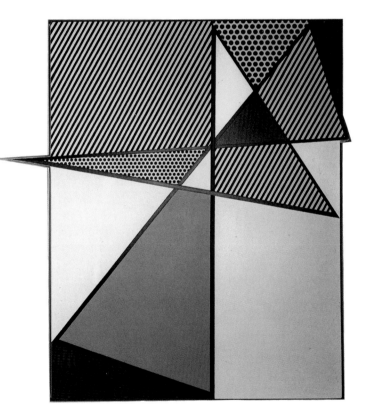

16 JOAN MITCHELL (American, 1925–1992)

Chord VII
1987
Oil on canvas
94 x 78 3/4 in.
Private collection

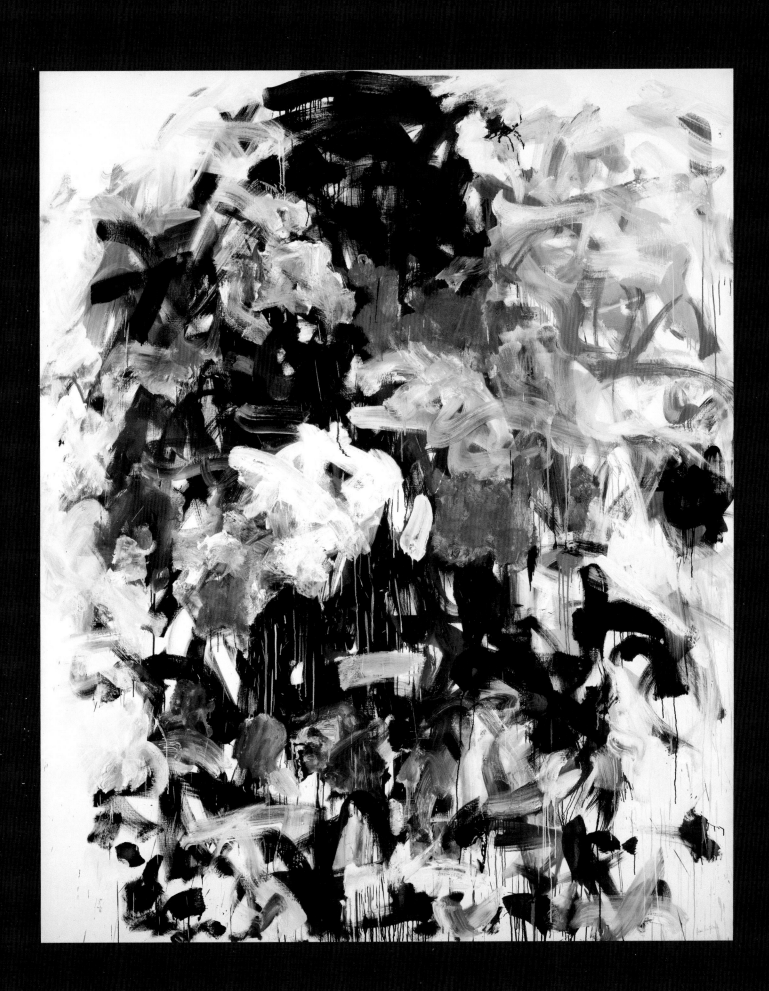

1 7 K E N T B E L L O W S (American, 1949–2005)

Susan at Marty's
1988
Pencil on paper
20 x 11 1/2 in.
Collection of Monica and Rick Segal

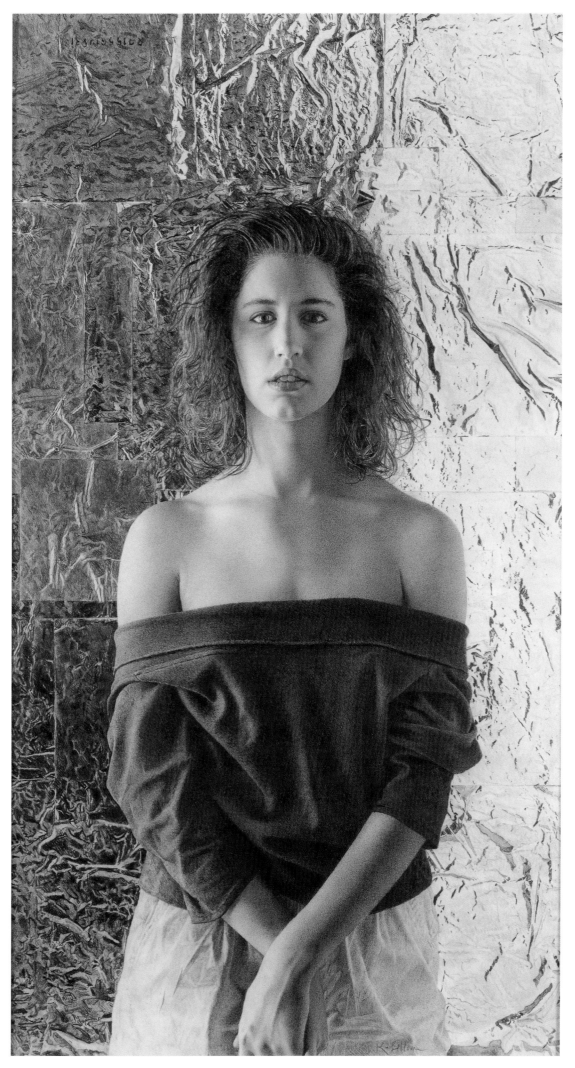

18 ED RUSCHA (American, 1937–)

Metro, Petro, Neuro, Psycho
1989
Acrylic and pencil on paper
42 1/2 x 56 1/2 in.
Private collection

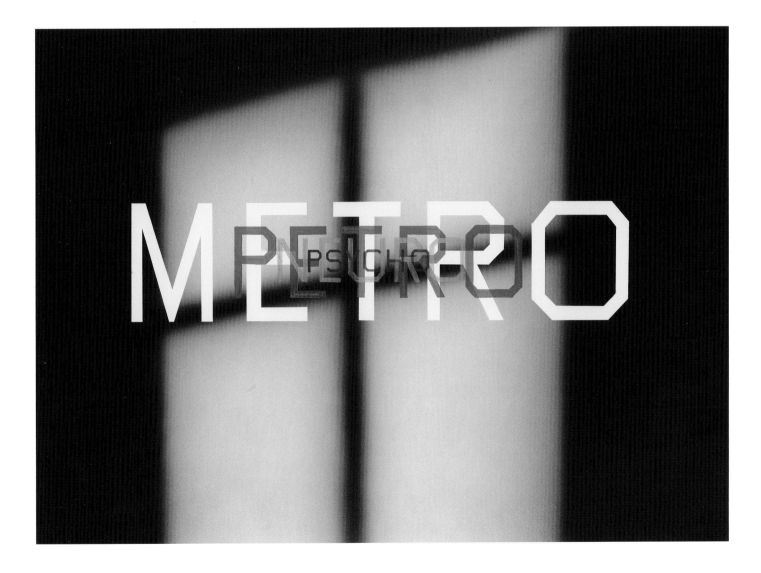

19 K I K I S M I T H (American, 1954–)

Daisy Chain
1992–93
Cast bronze, steel chain
Edition of 3 plus 1 A.P.
Installation dimensions variable
Private collection, New York

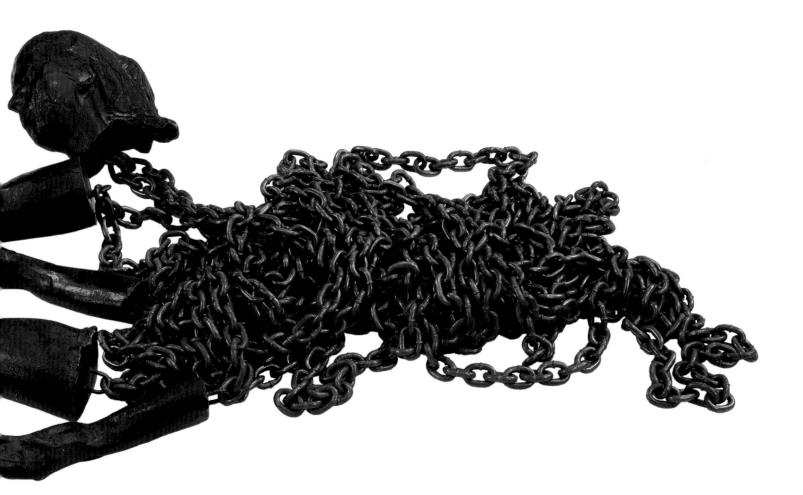

2 0 D A M I E N H I R S T (British, 1965–)

Away From the Flock
1994
Glass, steel, domestic lamb (*ovis aries*),
and formaldehyde solution
38 x 59 x 20 in.
The Steven and Alexandra Cohen Collection

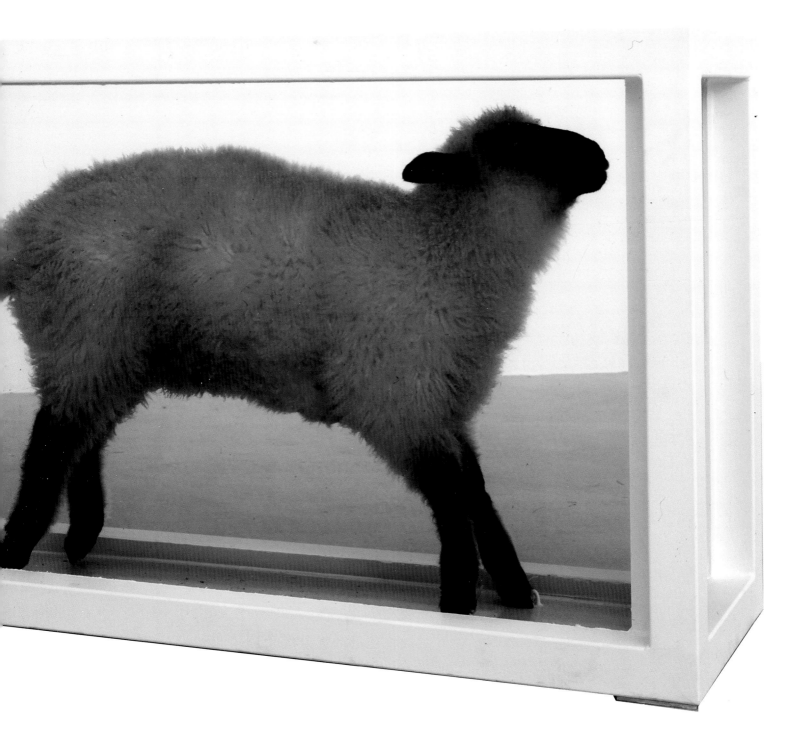

2 1 L O U I S E B O U R G E O I S (French/American, 1911–)

Spider
1997
Bronze and steel
Edition 1/6
94 x 96 x 84 in.
Private collection

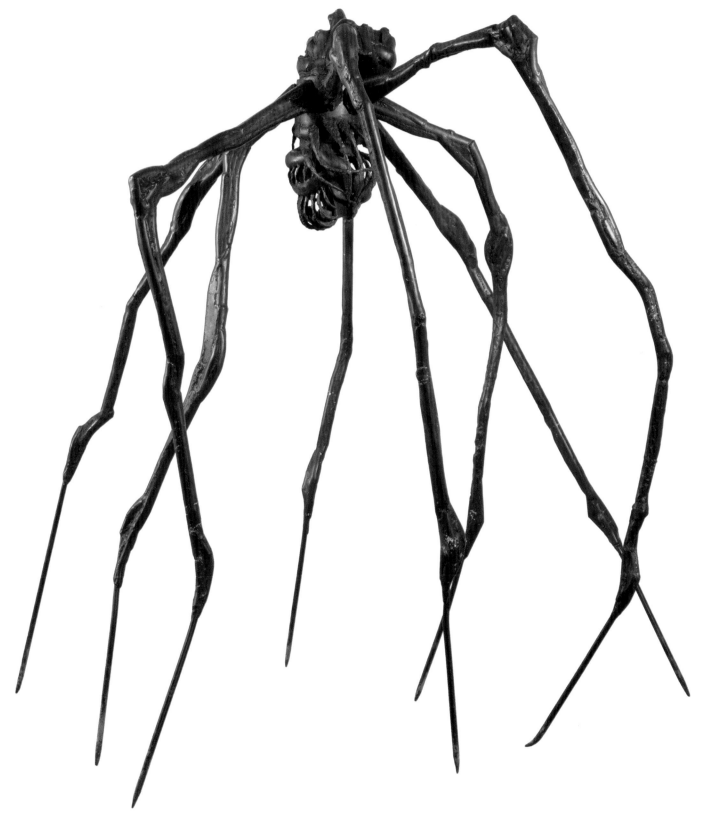

22 MAURIZIO CATTELAN (Italian, 1960–)

Cheap to Feed
1997
Taxidermied dog
16 x 14 x 6 1/2 in.
Collection of Danielle & David Ganek

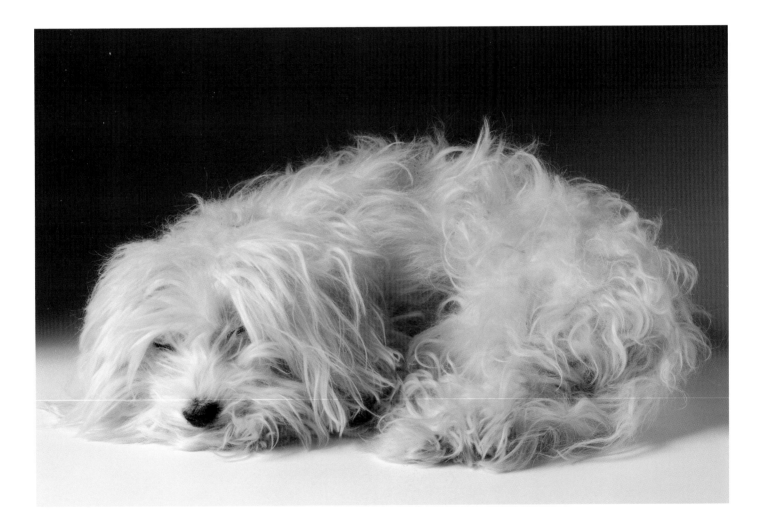

23 RICHARD PRINCE (American, 1949–)

Untitled (Cowboy)
1997–98
Ektacolor photograph
Edition 2/2 plus 1 A.P.
60 x 40 in.
Private collection

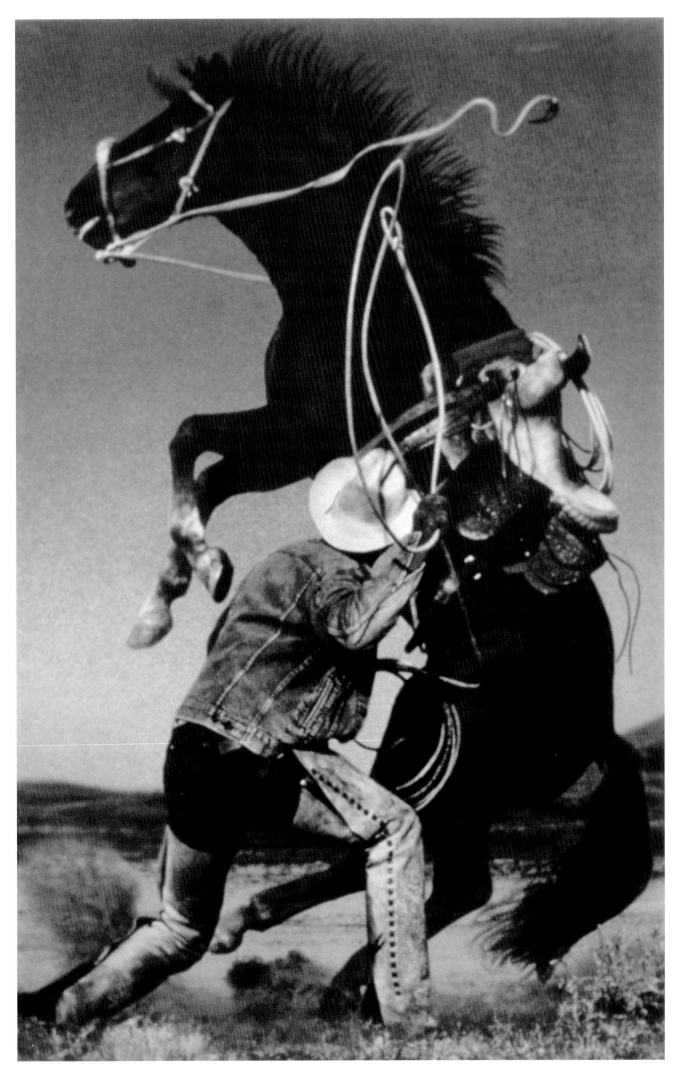

2 4 D A M I E N H I R S T (British, 1965–)

Beautiful Blue Comet Hurtling Towards
the Centre Painting (with Pastel Hues)
1998
Gloss household paint on canvas
72 in. diameter
Private collection

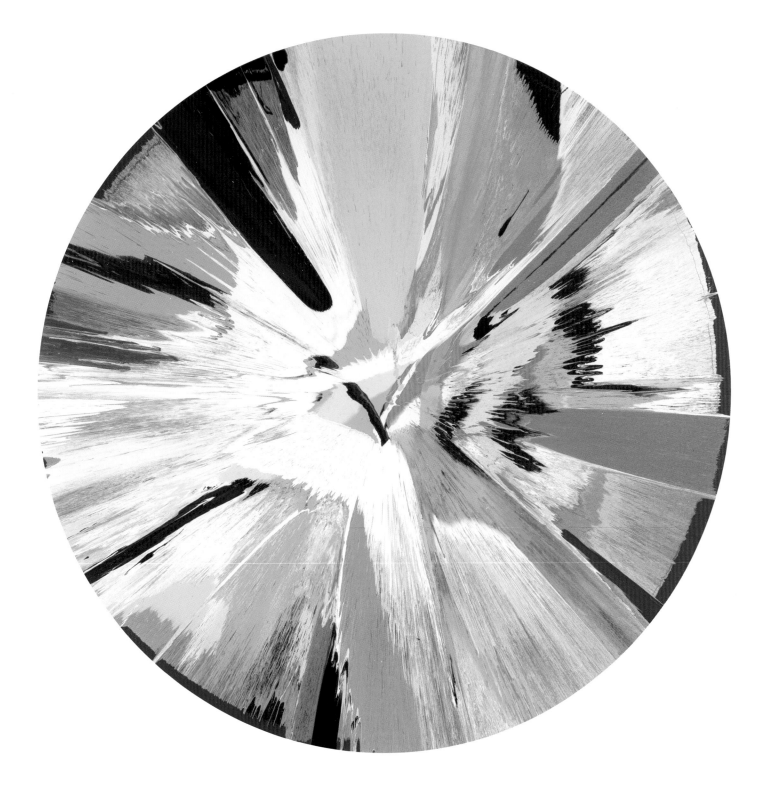

25 GAVIN TURK (British, 1967–)

Death of Marat
1998
Waxwork and mixed media in vitrine
78 3/4 x 98 3/8 x 67 in.
Private collection, New York

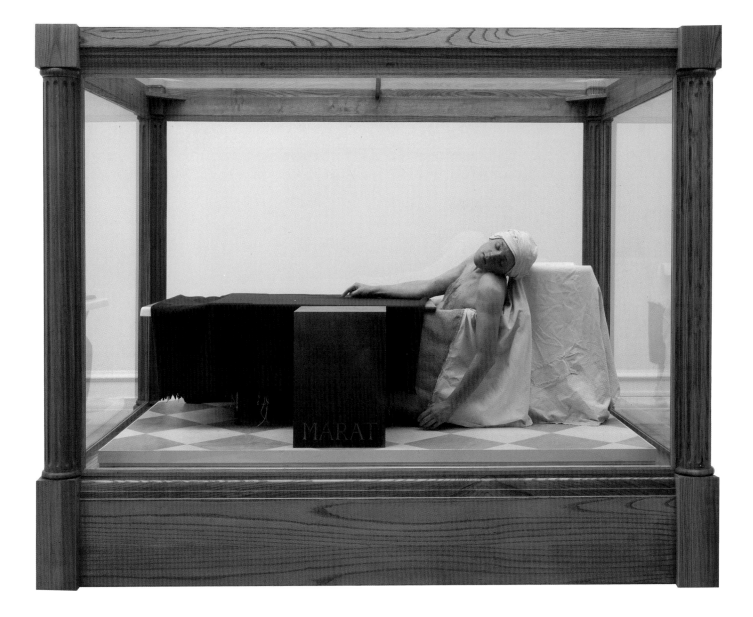

26 NICOLAS AFRICANO (American, 1948–)

Untitled (Reclining Nude)
1998
Cast glass, enamel paint
13 x 10 1/4 x 21 3/4 in.
Collection of Monica and Rick Segal

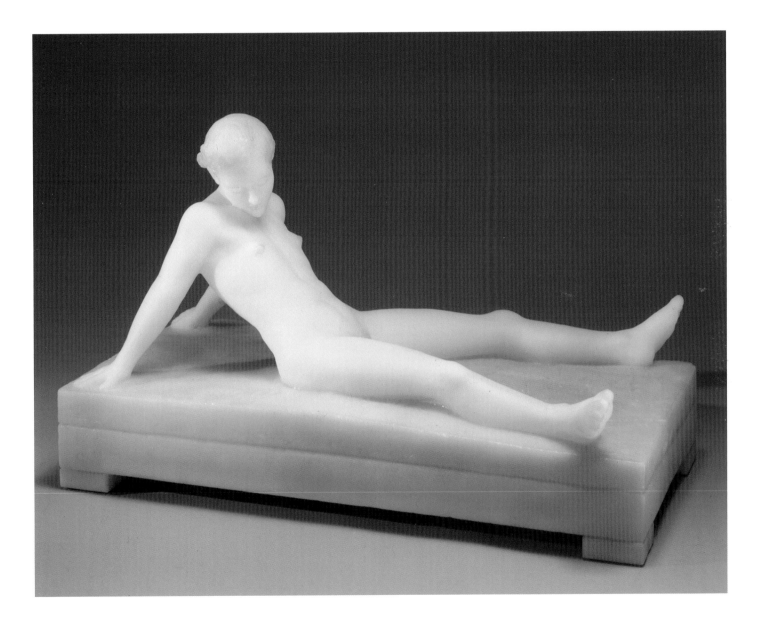

PETAH COYNE (American, 1953–)

Untitled #989 (Miss Scarlett)
1999–2000
Mixed media
64 x 44 x 26 in.
Private collection

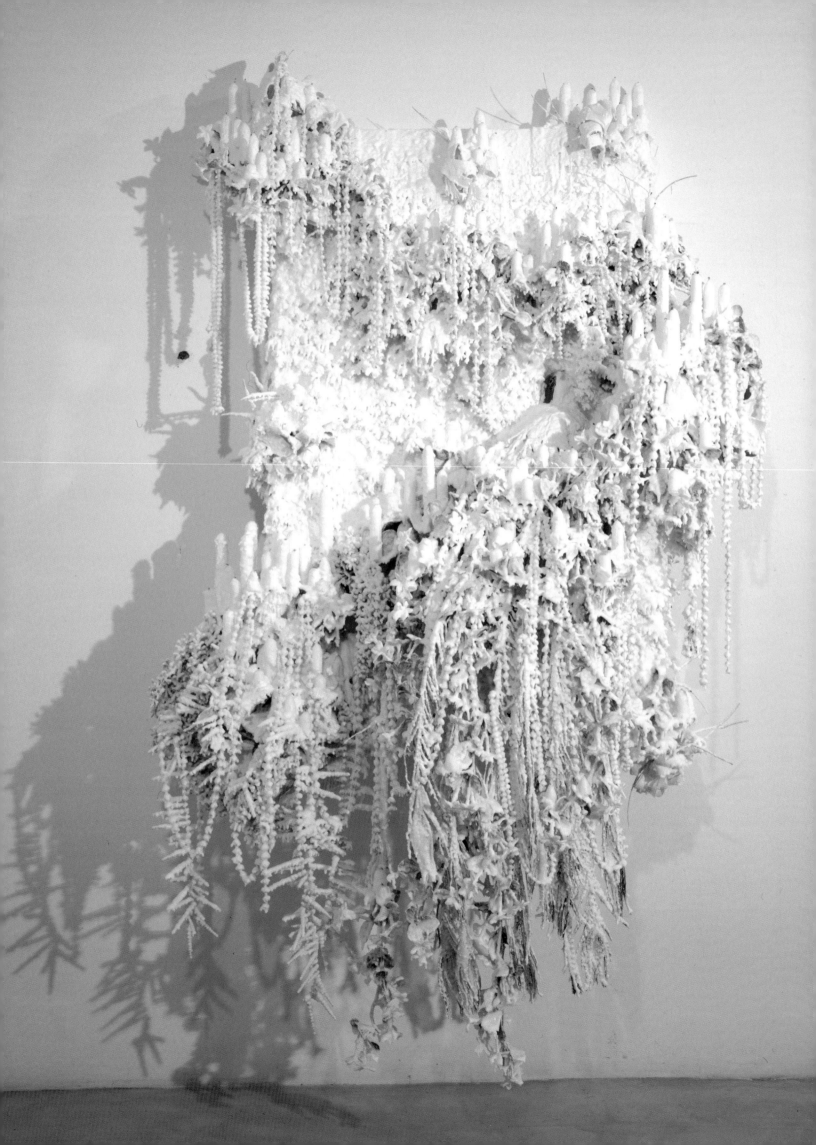

2 8 R O N M U E C K (British/Australian, 1958–)

Baby
2000
Mixed media
Edition 1/1 plus 1 A.P.
10 1/4 x 4 3/4 x 2 1/8 in.
Private collection, New York

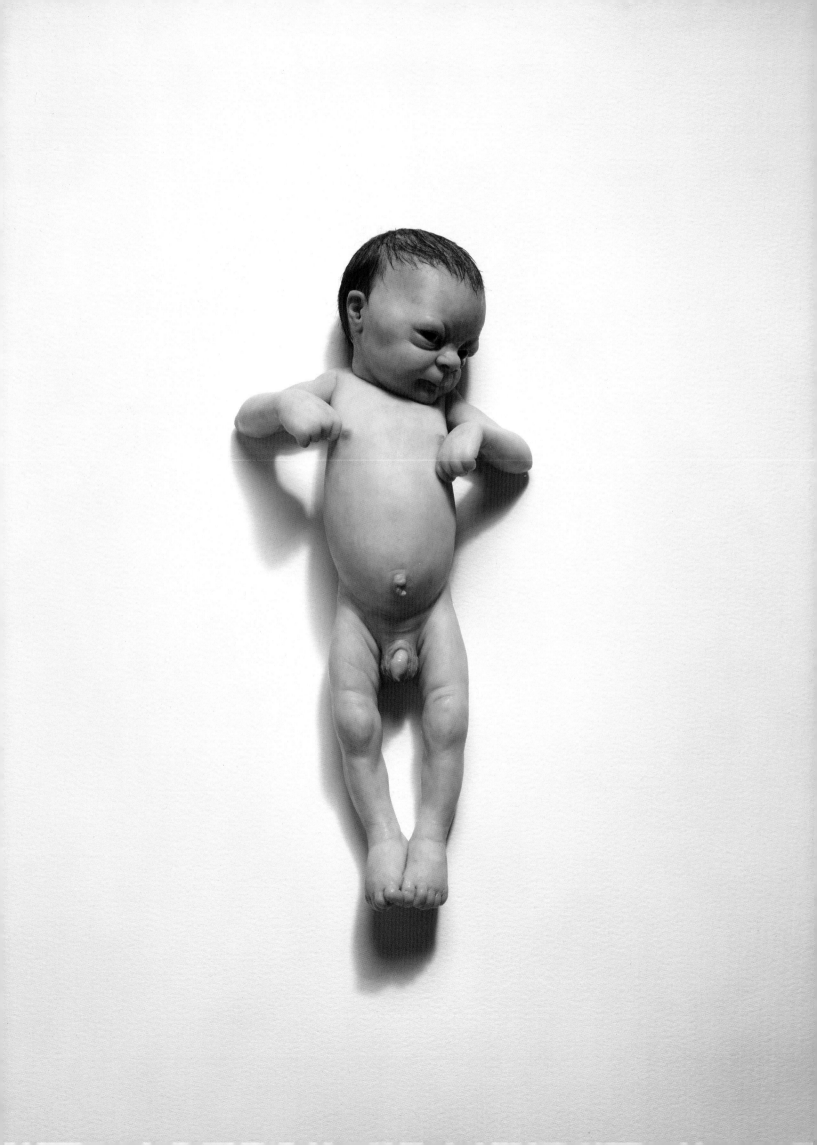

VANESSA BEECROFT (Italian, 1969–)

VB 52, Castello di Rivoli
2003
Type-C color photograph mounted on aluminum
Edition 2/3
50 x 63 in.
Private collection

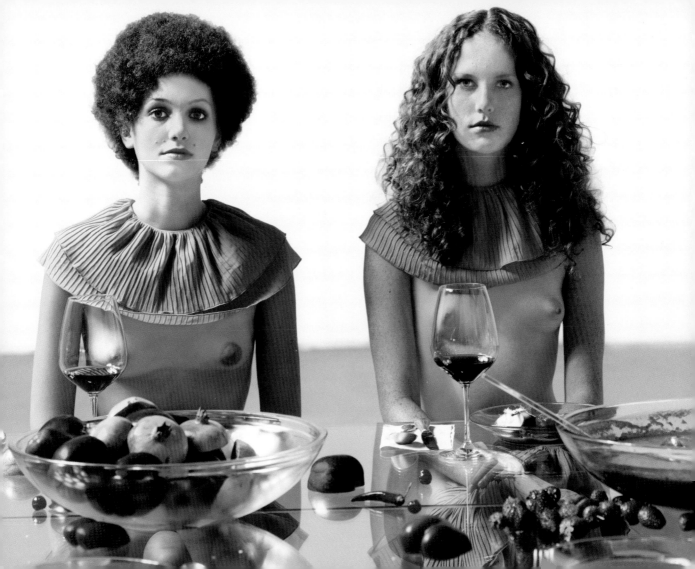

30 GRAYSON PERRY (British, 1960–)

He Comes Not in Triumph
2004
Glazed ceramic
20 7/8 x 11 3/4 in.
Collection of Monica and Rick Segal

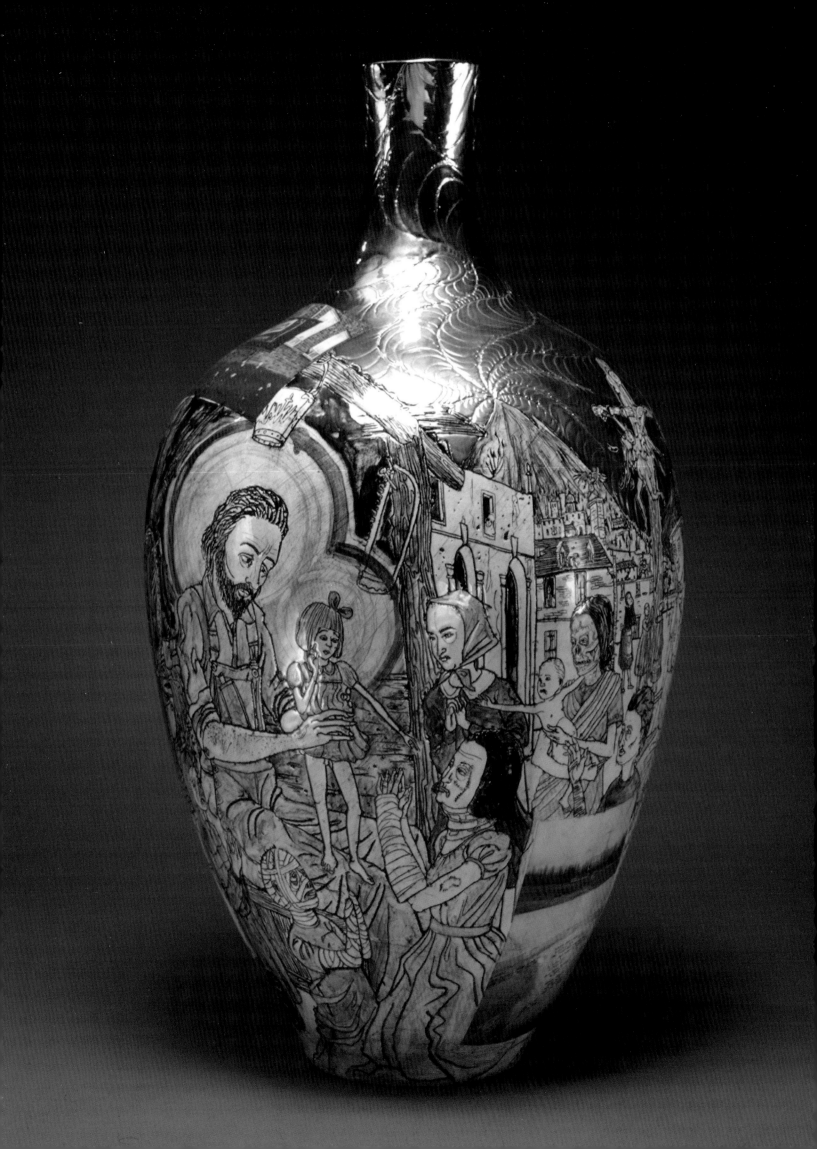

3 1 L A U R I E S I M M O N S (American, 1949–)

Long House (Red Bathroom/Blue Figure)
2004
Cibachrome print
Edition of 5 plus 2 A.P.
52 3/8 x 63 3/8 in.
Private collection, New York

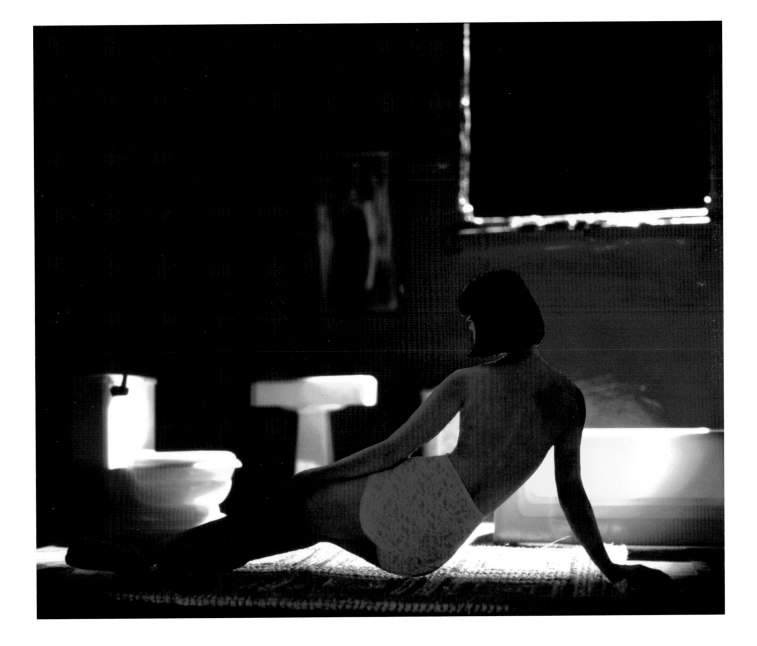

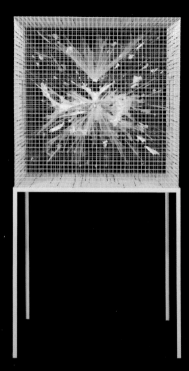

3 2 E . V . D A Y (American, 1967–)

Bridal Super Nova
2005
Various fabrics and accessories, monofilament,
welded powder-coated steel cage and stand
Edition of 3 plus 2 A.P.
42 x 42 x 40 in.; overall height 80 in.
Private collection

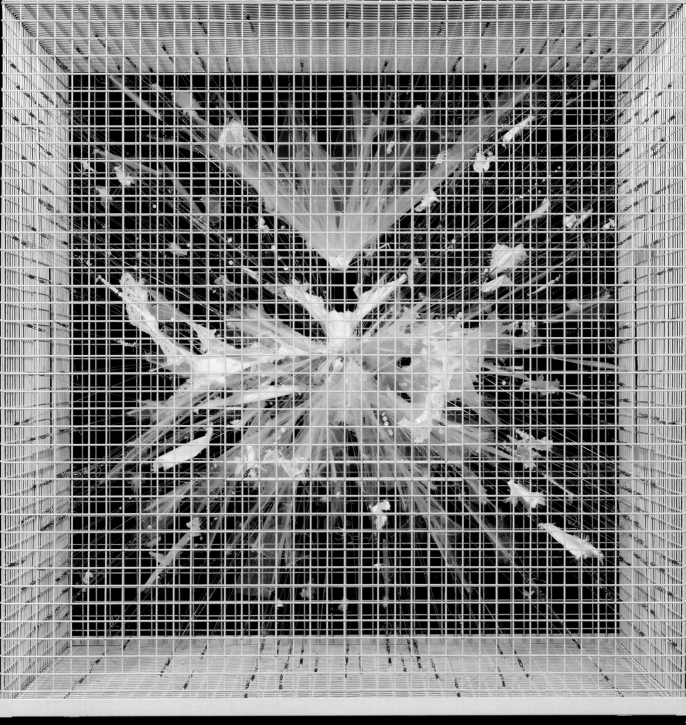

3 3 T A K A S H I M U R A K A M I (Japanese, 1962–)

Cherries
2005
FRP, steel, acrylic, urethane paint
78 x 39 x 27 3/4 in.
Collection of Danielle & David Ganek

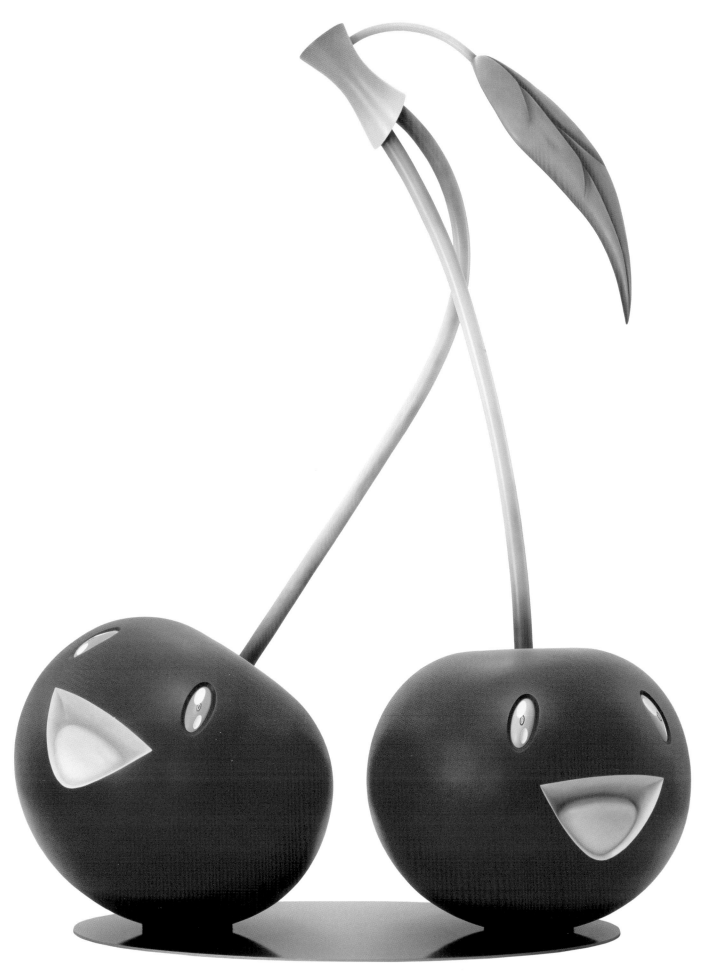

34 HILARY HARKNESS (American, 1971–)

Pearl Trader
2006
Oil on linen
30 x 33 in.
Collection of Jennifer Blei Stockman

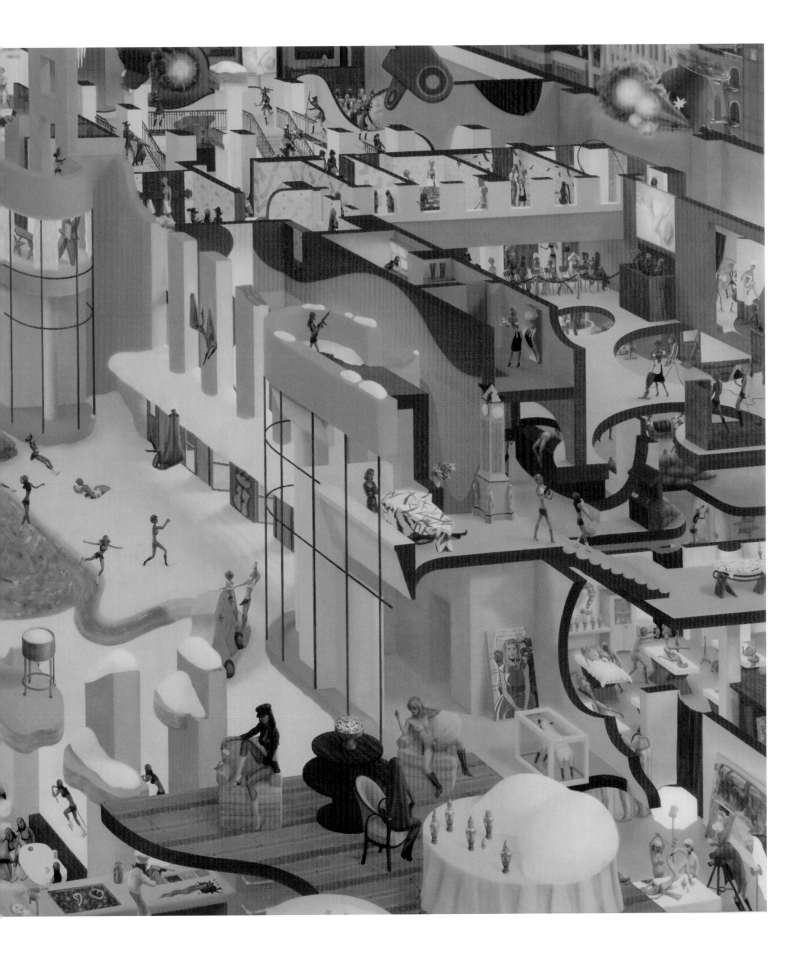

35 MARC QUINN (British, 1964–)

Sphinx (Fortuna)
2006
Painted bronze
Edition of 3
26 x 25 in.
Collection of Jennifer Blei Stockman

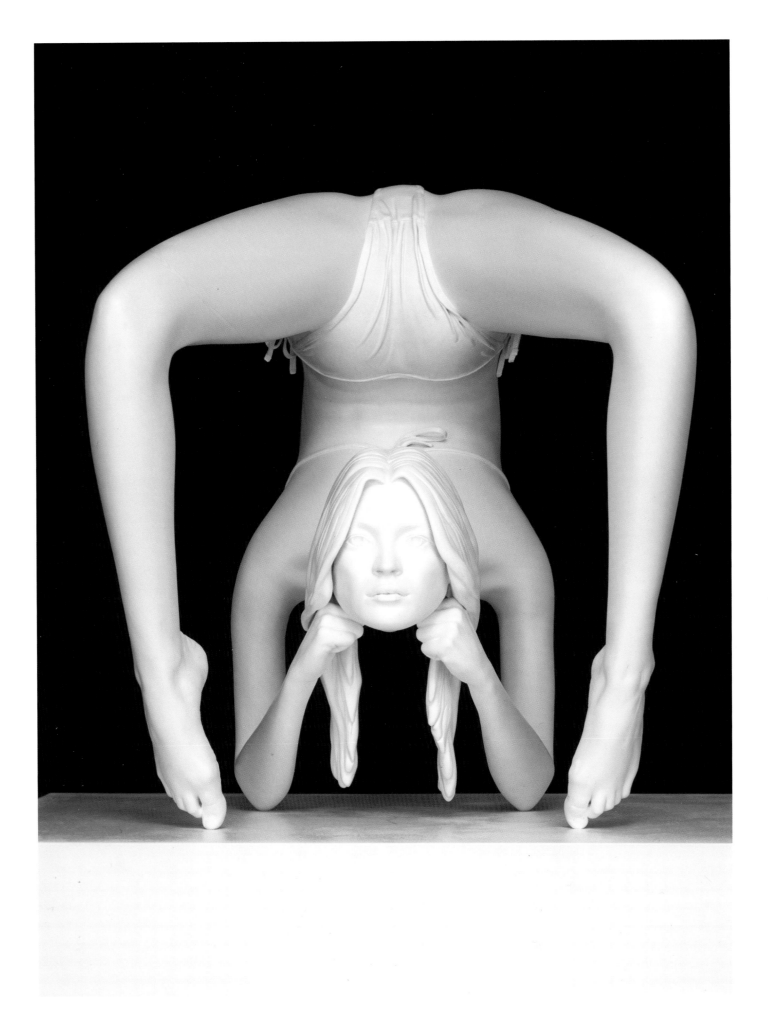

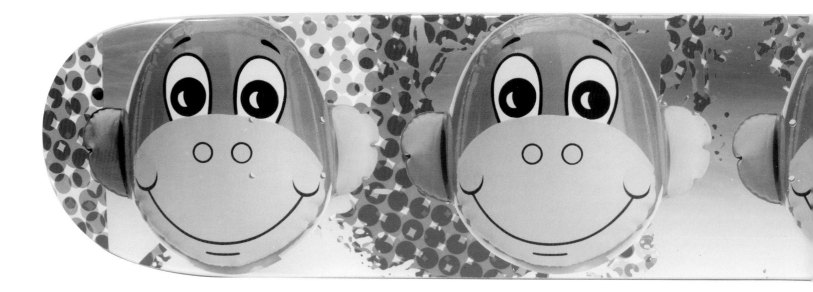

36 JEFF KOONS (American, 1955–)

Monkey Train
2006
Heat transfer print on wood skateboard, edition of 400
Published by Supreme with unique drawing in silver
marker signed/dated *2007*
31 x 7 3/4 in.
The Stephanie and Peter Brant Foundation,
Greenwich, Connecticut

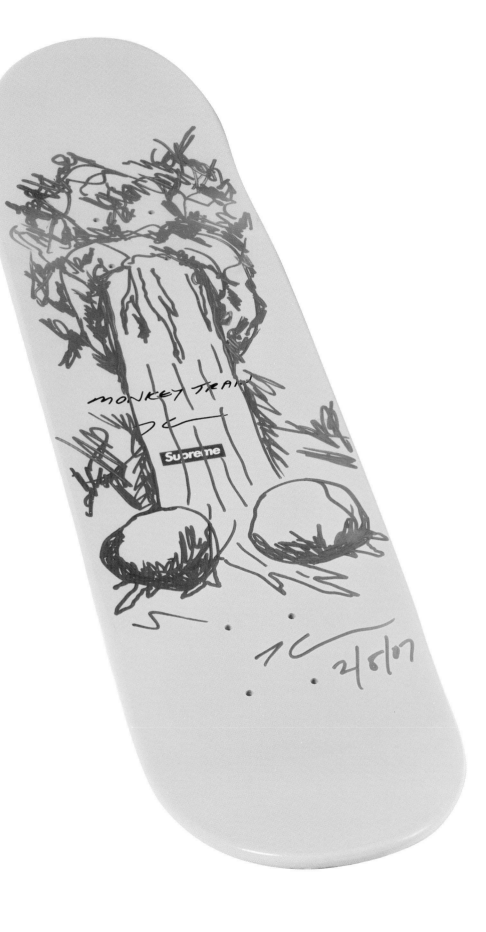

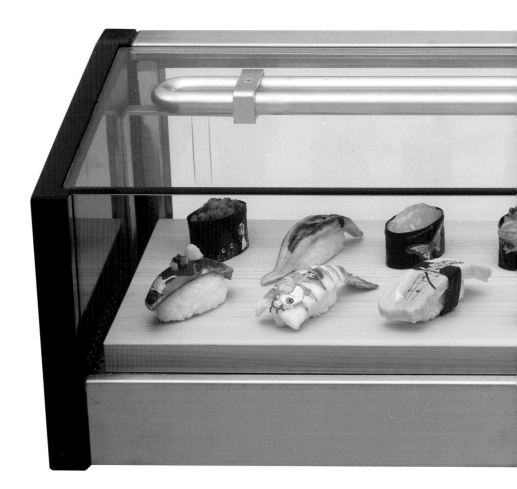

37 MAHOMI KUNIKATA (Japanese, 1979–)

Maho Sushi Favorite Assortment
2006
Acrylic on plastic food sample, iron, glass, wood
2 3/4 – 4 in. each; 33 1/2 x 40 in. overall
Collection of Jennifer Blei Stockman

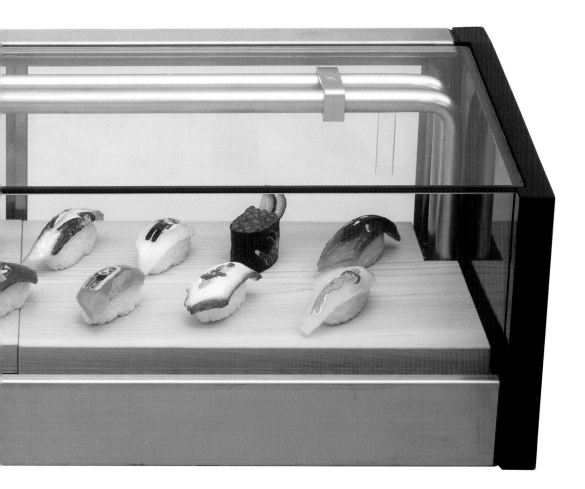

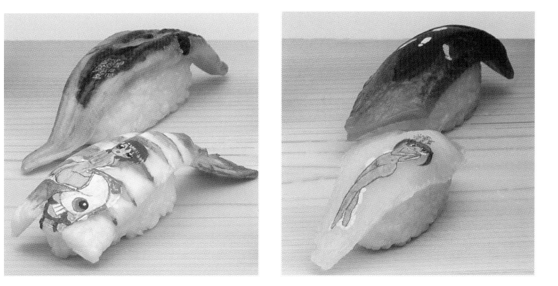

3 8 S A R A H L U C A S (British, 1962–)

Gnorman
2006
Plastic cast gnome and cigarettes
11 3/8 x 7 7/8 x 7 1/2 in.
Collection of Monica and Rick Segal

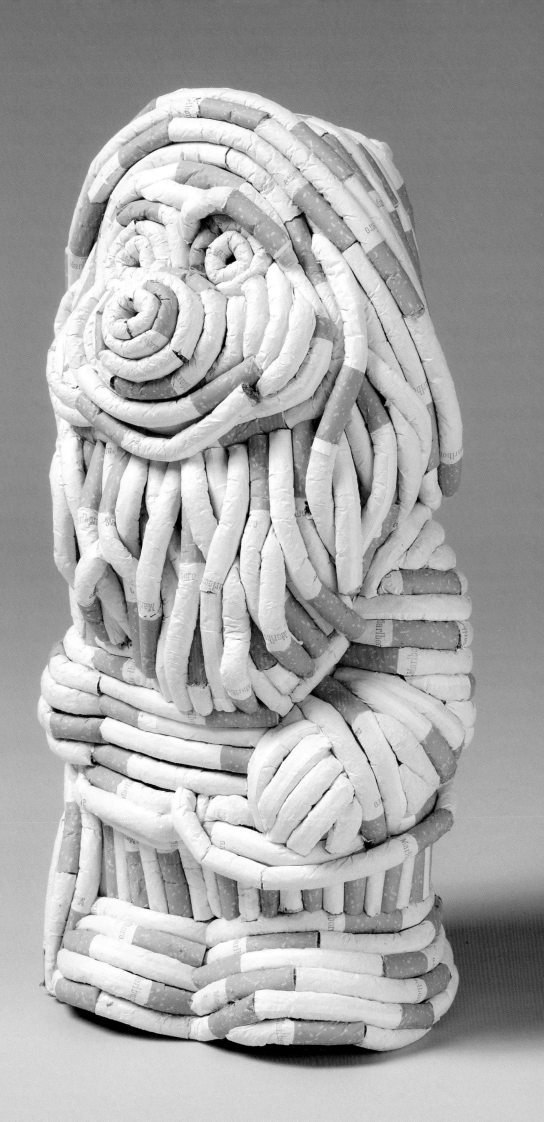

39 CHRISTIAN MARCLAY (American, 1955–)

Silence (The Electric Chair)
2006
Silkscreen on colored paper
22 1/4 x 30 1/16 in.
Collection of Pamela and Arthur Sanders

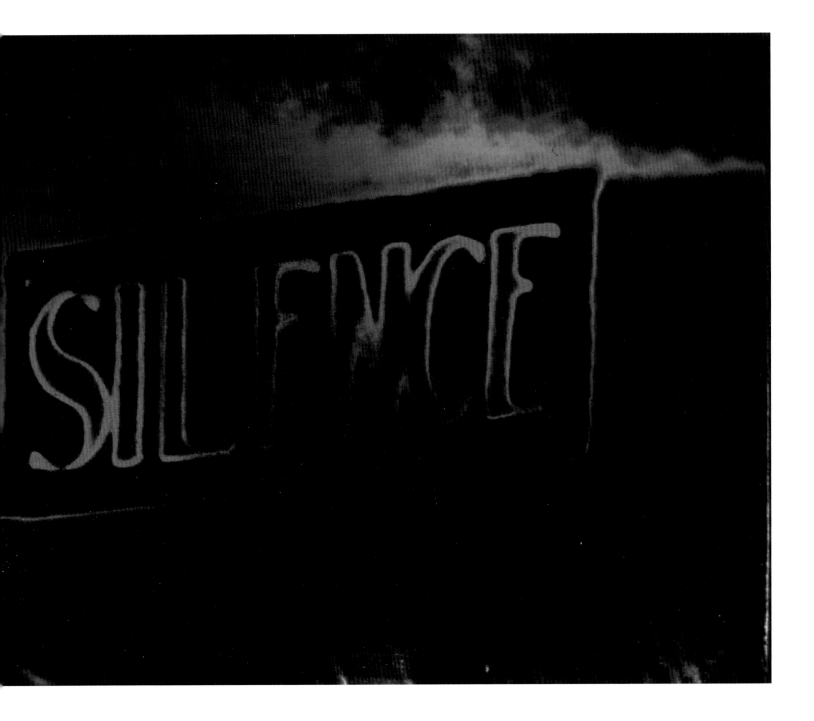

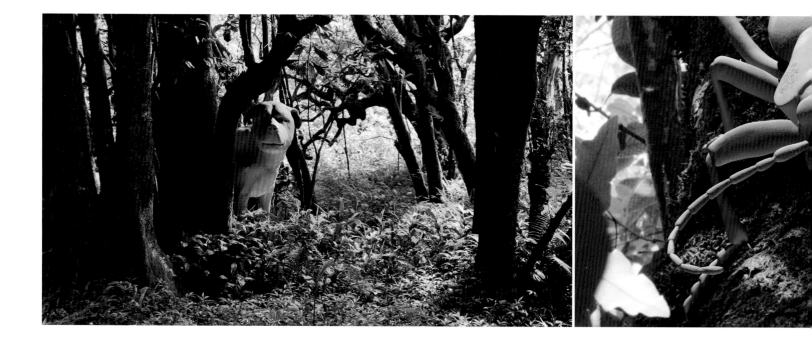

40 JOSHUA MOSLEY (American, 1974-)

dread
2007
Mixed media animation (6 minutes) and
five bronze sculptures
Edition of 6 plus 1 A.P. and edition of 5 without
sculptures
Collection of Jennifer Blei Stockman

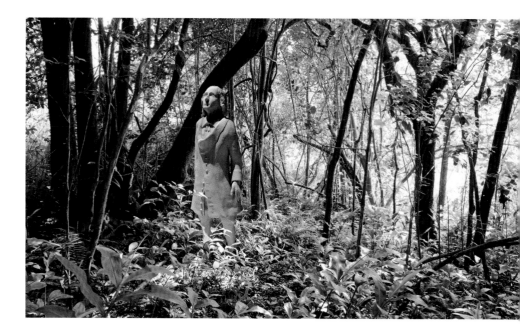

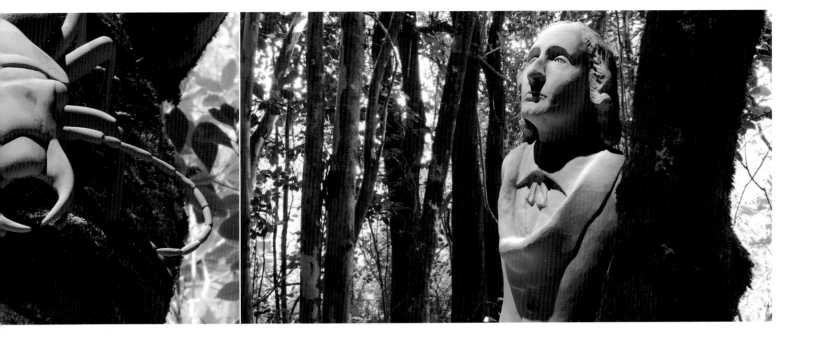

he is neither here nor good.

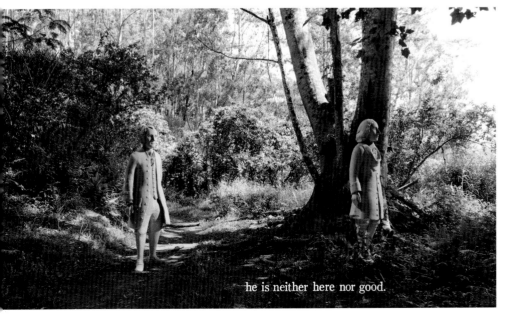

he is neither here nor good.

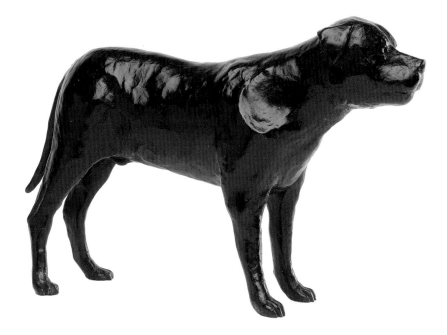

JOSHUA MOSLEY (American, 1974–)

The five sculptures that accompany *dread*, 2007:

a *Dread*
2007
Bronze
10 1/4 x 15 3/4 x 4 1/8 in.

b *Pascal*
2007
Bronze
12 x 6 1/2 x 3 in.

c *Rousseau*
2007
Bronze
12 1/8 x 5 x 4 in.

d *Anthia Sexguttata*
2007
Bronze
6 1/4 x 16 1/8 x 13 1/4 in.

e *Cow*
2007
Bronze
9 x 15 1/2 x 4 in.

Collection of Jennifer Blei Stockman

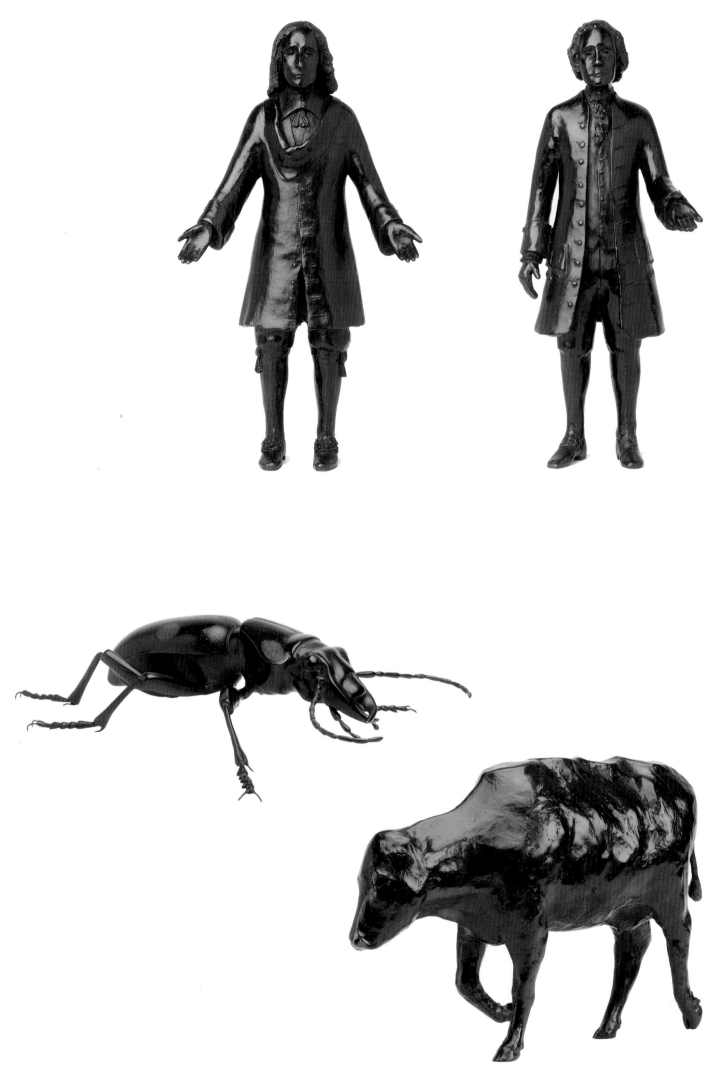

Rights and Reproduction
Photographs of works of art reproduced in this volume have been provided in many cases by the artists' representatives, owners or custodians of the works. Individual works of art appearing herein may be protected by copyright in the United States of America or elsewhere, and may thus not be reproduced in any form without the permission of the copyright owners. The following and/or other photograph credits appear at the request of the artists's representatives and/or owners of individual works.

1	© 2007 Jim Dine / Artists Rights Society (ARS), New York
2	Art © James Rosenquist/Licensed by VAGA, New York, NY
3	© The Estate of Eva Hesse. Hauser & Wirth Zürich London. Photo credit: Paul Mutino
5	© 2007 Estate of Sol LeWitt / Artists Rights Society (ARS) New York. Photo credit: Paul Mutino
6	© 2007 Estate of Sol LeWitt / Artists Rights Society (ARS) New York. Photo credit: Paul Mutino
7	© 2007 Andy Warhol Foundation for the Visual Arts / ARS, New York
8	© 2007 The Saul Steinberg Foundation / Artists Rights Society (ARS), New York
9	© David Hockney
10	© 2007 The Estate of Jean-Michel Basquiat / ADAGP, Paris / ARS, New York
11	© Cy Twombly
12	© Chuck Close, courtesy PaceWildenstein, New York. Photograph by: Maggie L. Kundtz
13	Courtesy of the artist and Marian Goodman Gallery, New York. Photo credit: Paul Mutino
14	Art © Jasper Johns/Licensed by VAGA, New York, NY. Photo credit: Paul Mutino
15	© Estate of Roy Lichtenstein
16	All works by Joan Mitchell © The Estate of Joan Mitchell
17	Reproduced with permission from The Kent Bellows Foundation. Photo credit: Paul Mutino
18	© Ed Ruscha

photography credits

19	© Kiki Smith, courtesy PaceWildenstein, New York. Photograph by: Ellen Page Wilson
20	© the artist, courtesy of Science, Ltd. Photography by Stephen White
21	Art © Louise Bourgeois/Licensed by VAGA, New York, NY
22	Courtesy of the artist and Marian Goodman Gallery, New York. Photo credit: Paul Mutino
24	© the artist, courtesy of Science, Ltd.
25	© the artist Courtesy Jay Jopling/ White Cube (London)
26	© Nicolas Africano, courtesy Nancy Hoffman Gallery
27	© Petah Coyne. Courtesy Galerie Lelong, New York. Photography: Wit McKay
28	Courtesy of the Artist and Anthony d'Offay, London
29	© 2003 Vanessa Beecroft. Photo by Nic Tenwiggenhorn
30	Courtesy of Victoria Miro Gallery. Copyright The Artist.
31	Courtesy Sperone Westwater, New York
32	Courtesy Carolina Nitsch Contemporary Art, New York. Photo credit: Paul Mutino
33	Courtesy Galerie Emmanuel Perrotin, Paris & Miami / Blum & Poe, Los Angeles / Marianne Boesky Gallery, New York. ©2005 Takashi Murakami/Kaikai Kiki Co., Ltd. All Rights Reserved.
34	Courtesy: Mary Boone Gallery, New York
35	Courtesy: Mary Boone Gallery, New York
36	© Jeff Koons. Photo credit: Paul Mutino
37	© 2006 Mahomi Kunikata/Kaikai Kiki Co., Ltd. All Rights Reserved.
38	Copyright the artist. Courtesy Sadie Coles, HQ, London, and Gladstone Gallery, NY. Photo credit: Paul Mutino
39	Courtesy Paula Cooper Gallery, New York
40	Courtesy Donald Young Gallery, Chicago